Beckmann Carnival

ISBN 0 946590 08 7
Published by order of the Trustees 1984
Copyright © 1984 The Tate Gallery
Designed and published by the Tate Gallery Publications
Department, Millbank, London SW1P 4RG
Printed by The Hillingdon Press, Uxbridge, Middlesex

SARAH O'BRIEN TWOHIG

Beckmann Carnival

THE TATE GALLERY

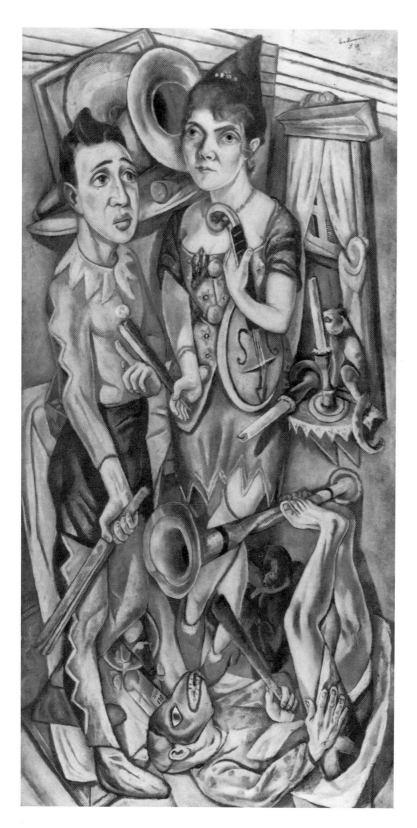

1 Max Beckmann (1884–1950)
Carnival 1920
Oil on canvas, 186.2 × 91.8 cm
Purchased by the Tate Gallery in
1981 with assistance from the
National Art-Collections Fund,
Mercedes-Benz (U.K.) Ltd and
the Friends of the Tate Gallery

Introduction

In 1981 the Tate Gallery's collection of twentieth-century German art was tremendously enriched by the purchase of 'Carnival' 1920 – the haunting picture by Max Beckmann which forms the subject of this booklet.

Beckmann was born a century ago this year but it is only recently that his achievement has been accorded anything like proper recognition in this country. 'A towering and somewhat solitary figure',[1] he belonged to no movement or school. He was not an Expressionist, and even though his work of the twenties was identified at the time with the new, objective mood of German painting known as *Neue Sachlichkeit*, its concerns differed significantly from those of a George Grosz or an Otto Dix. Certainly Beckmann's harsh realism charted the moral, social and political upheavals of the infant Weimar Republic, but it did so in a way that stressed emblem and allegory rather than satire. And by the time he came to paint 'Carnival', the first of many pictures on the theme of masquerade, Beckmann had developed a complex and mysterious symbolism to express his tragic view of human nature.

The task of unlocking those symbols has been boldly undertaken by Sarah O'Brien Twohig, who also places 'Carnival' in the historical and personal circumstances in which it was created. In 1920 Beckmann was living at Frankfurt am Main where five years previously he had gone to recover from his harrowing experiences as a hospital orderly on the Belgian Front. In September 1914 he volunteered for the German army medical corps and was sent to the Eastern Front before being transferred to Flanders early in 1915. He served first in a typhus hospital and then in an emergency field station. 'There', as Peter Selz has written, 'in a small room above the emergency operating room he really looked horror in the face every day and sketched what he saw.'[2] That summer he was discharged from the army suffering from nervous exhaustion. What he had witnessed marked him for life and changed the course of his art.

But it was not only Beckmann's daily contact with death that radically affected his style. In April 1915 he writes home from Brussels, where he has been spending a few days' leave, with a list of artists who most impressed him on a visit to the museum: Bruegel, Roger van der Weyden, a portrait by Cranach, and 'some unknown German primitives who seemed wonderful to me on account of their brutal, rough intimacy and robust, almost peasant-like strength'.

'These pictures', he continues, 'endlessly stimulated and strength-

ened me. I felt close to them all and was at home in a hostile land.'[3]

Beckmann passionately admired late medieval art and, like many of his contemporaries, found inspiration in the portrayal of intense emotion and suffering in Grünewald's Isenheim Altarpiece. In 1914 he even wrote to Wilhelm von Bode urging him to have the altarpiece brought from Colmar to the museum in Berlin, where it would be safe from possible war damage.

Another late Gothic artist of interest to Beckmann was the Nuremberg sculptor and painter Veit Stoss, whose most famous work is probably the magnificent carved altarpiece at Cracow. Reproductions of Stoss's engravings were published in Berlin in 1913 by Bruno Cassirer, who later published Beckmann's war letters; and in 1916 Curt Glaser illustrated two wings of Stoss's St Kilian's Altarpiece from the parish church at Münnerstadt, Bavaria, in his *Zwei Jahrhunderte deutsche Malerei* (Two centuries of German painting), a book Beckmann owned. The paintings depict the murder of St Kilian and subsequent trial of his murderer. On one of them Beckmann based the composition of

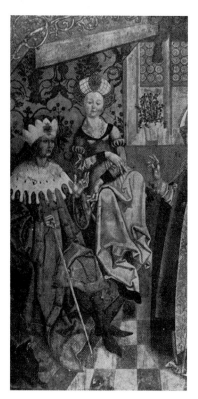

2 Veit Stoss, wing of the St Kilian's Altarpiece, Münnerstadt (from Curt Glaser, *Zwei Jahrhunderte deutsche Malerei*, Munich 1916)

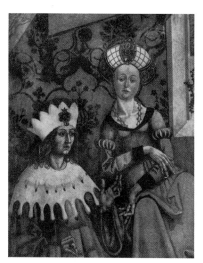

3 St Kilian's Altarpiece (detail)

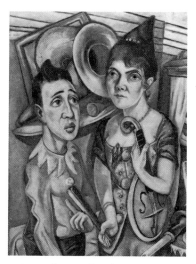

4 **Carnival** 1920 (detail)

'Carnival', following Stoss in the placing of the window with an object on the sill (a flower pot appears in the Second and Third Sketches) and in the arrangement of the central couple, even down to the bent knee and soft shoes of the male figure. There are further echoes, particularly in the shallow space, tilted architecture – Beckmann puts coving where Stoss has some kind of a beam or lintel – and elaborate hand gestures of the figures. The main difference is of course the presence of the clown lying on the floor in 'Carnival', a detail for which there is no prototype in Stoss.

The theatricality of Veit Stoss's figure compositions, with their exaggerated bodily movements, long pointing fingers and heightened facial expressions, all compressed into a taut rhythmical pattern, clearly appealed to Beckmann and helped him move beyond realism to create what has been called 'his own highly subjective world of human symbolism'.[4]

Richard Calvocoressi
Assistant Keeper, Modern Collection

[1] Gabriel White, Foreword to Arts Council exhibition catalogue *Max Beckmann 1884–1950*, Tate Gallery, October–November 1965, p.3.
[2] Peter Selz, *Max Beckmann*, New York, 1964, pp.21–22.

[3] *Briefe im Kriege*, Berlin, 1916, pp.40–41.
[4] Peter Selz, *German Expressionist Painting*, Los Angeles, 1974 edition, p.284.

Beckmann **Carnival**

Of the dramatic quality of Max Beckmann's 'Carnival' there can be no doubt. Tall and narrow like a Gothic altarpiece, it depicts three people in fancy dress, holding musical instruments and carnival slapsticks, crowded close together in the corner of an illogically small, perspectively distorted room.

Its German title, 'Fastnacht', denotes the climax to the season of fancy dress parties, masked balls and street processions characterized by wild music and dancing, which in Catholic countries and regions takes place between mid-January and the beginning of the Lenten period of fasting and penance on Ash Wednesday.[1] *Fastnacht* thus traditionally symbolizes the vanity, futility and transience of the world, and serves to remind men of their ultimate destiny.

The first of the nine extant composition sketches for the painting is dated 22.2.1920, just five days after the end of that year's carnival. 1920 was, significantly, the only year the Frankfurt police banned all public carnival festivities and even refused to extend the legal closing time for restaurants and dance halls in an attempt to curb what they considered wasteful expenditure in a period of rampant inflation.[2] Many people in Frankfurt defied the ban and held illegal balls; however, the usual frenzy of *Fastnacht* was that year markedly subdued. This could be one reason for the restrained atmosphere of 'Carnival', celebrated surreptitiously in a domestic interior.

The painting was presumably well under way by 9 July 1920, when Beckmann and Israel B. Neumann, his Berlin dealer, who appears in the painting, drew up a joke contract on the back of an impromptu café sketch, in which Neumann agreed to buy 'Carnival' for 25,000 marks, payable by 1 November 1920.[3] A joke on one level, perhaps, especially the inflationary sum, but Neumann immediately recognized the importance of the completed work, and offered Beckmann whatever price he wished to set on it.[4]

The Painting

Every inch of the picture surface reverberates with the syncopated rhythms of brightly contrasting reds and greens, blues and oranges, evoking the wild cavorting of the carnival. Staccato zigzag patterns and steep diagonal shapes cause the spectator's eye to shift to and fro in a never-ending ebb and flow of hectic movement. At no point does the

composition offer any hint of eventual respite: there is no single focal point on which the eye may come to rest. It is almost as though we are witnessing a dance without end.

The spectator is then struck by the curious fact that all this bustling activity is simultaneously negated by the figures' strangely awkward, rigid stance. They look as if they have been asked to hold their poses for a long-exposure photograph, or even as though they are actors frozen in a shot from a silent Expressionist film. And their faces, instead of expressing the light-hearted merriment normally associated with carnival, seem to be suffused with a deadly earnest, bordering on melancholy. Indeed, so preoccupied are they with their reflections that they scarcely seem to be aware of each other's presence.

The spectator thus experiences each figure in isolation and is then faced with the paradox that despite this mental distance, the pictorial structure welds the figures into a precisely defined, intimate physical relationship which has all the finality of pieces in a jigsaw puzzle.

The more we look at the picture the more discrepancies we observe. Far from being a straightforward description of an event, it seems to present us with a series of questions. At this point, we either dismiss it as nonsensical, or else our curiosity is aroused. What are they doing? Why are they so stiff and unnatural? Why are they cramped into such a small space? Why do they look so serious at a carnival party? Why is the masked figure on the floor holding a trumpet crazily aloft between his feet? Who are they? Yet every gesture seems so deliberate, the position of every figure and object so precise, that we intuitively sense an underlying meaning to its apparent arbitrariness.

In an age accustomed to the intellectual abstractions of Cubism and non-figurative art, to the Expressionist exposure of emotion and to the Surrealist exploration of the unconscious, Beckmann's 'Carnival' remains curiously powerful and almost uncomfortably alive. Its style seems to fall outside any of the categories of twentieth-century aesthetic we have grown to absorb and accept, though in some strange way it seems to contain echoes of them all.

The casual observer of 'Carnival' is probably as disturbed now as he was in 1920 by the uneasy truce the artist has contrived to strike between painstakingly detailed realism on the one hand, and the arbitrary dislocation of proportion and space on the other. Individually, things are easily identifiable; seen in this context, nothing seems really knowable.

The psychological tension Beckmann establishes between his protagonists and their environment clearly expresses a diametrically opposed evaluation of man's relation to the harsh reality of post-war Europe than that reflected in the humanistic logic of Picasso's contemporaneous Neo-Classicism or Léger's heroic rationalization of man's role in the machine age.

The style of 'Carnival' exemplifies almost to the letter the elliptical

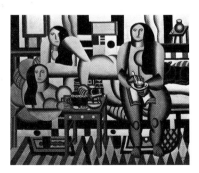

5 Fernand Léger,
Le Grand Déjeuner 1921
Museum of Modern Art, New York

definition of Beckmann's post-war artistic aims written at Neumann's request in 1917: 'I do not have much to write. To be the child of your time. Naturalism against your own Self. Objectivity of the inner face. My heart goes out to the four great painters of masculine mysticism: Mälesskircher, Grünewald, Bruegel and Van Gogh.'[5] Its brevity, due in part no doubt to Beckmann's well-documented taciturnity, also reflects his extreme defensiveness towards the art establishment at the time. Reaction in Germany ranged from incomprehension to outright hostility when, in 1915, he abandoned his pre-war naturalistic virtuosity for an intensely expressive realism characterized by aggressively distorted forms, agitated rhythms, dislocated spaces and sparsely textured surfaces.

Perceptive observers, however, such as the artist Alfred Kubin, realized that Beckmann must have been subject to the most terrible pressure to reject all his former skill and beauty of composition.[6] Beckmann reiterated this in his 1918 'Artistic Confession': '. . . the deeper and more fiercely my despair about existence burns within me, the more determined I become, with lips tightly sealed, to capture the disgusting, throbbing monster of vitality, and to capture it, suppress it, even throttle it in crystal-clear, incisive lines and surfaces'.[7]

In September 1919 Heinrich Simon published a reasoned and sympathetic analysis of Beckmann's artistic metamorphosis. With revealing insight he argued that despite the frequent brutality of Beckmann's tragic vision of post-war chaos, he nevertheless created a new kind of 'modern' beauty through his brilliantly precise draughtsmanship and his subtle, painterly use of colour. Simon's defence of the artist's much criticized expressive distortion is especially relevant to 'Carnival': 'The physical transformation of his figures is determined by the intellect . . . Beckmann's starting point is a totally sensuous, i.e. natural, conception of the human body. But in an ecstasy of sensibility, physical expression and gesture are heightened to the point of exaggeration. The head, being the element which most strongly conveys spiritual qualities, is enlarged, so too the limbs as obvious symbols of our cramped, distorted existence.'[8]

Over half a century later, innured by prolonged exposure to Surrealism and the various expressionist tendencies in art since 1945, Beckmann's deliberate 'naturalism against your own Self' and expressive distortion now seem less disturbing to us; if anything, it is his very restrained use of expressive devices which perplexes. Of these, the most effective in 'Carnival', and the one which determines our overall reaction to the work, is his psychological manipulation of space.

Even before he began to be seriously affected by the horrific suffering he witnessed as a voluntary medical orderly in the field hospitals of Flanders, Beckmann noted with distress how the anonymity of war threatened to erode his sense of self, which he had hitherto thought inalienable, while at the same time making him acutely aware of his

spiritual isolation. Filled with wonder at his fellow soldiers' ability to turn a blind eye to this psychological assault, he wrote to his wife from the Front in May 1915: 'Oh, this infinite space! We must constantly fill up the foreground with junk so that we do not have to look in its frightening depth. What would we poor people do, if we could not always come up with some idea, like patriotism, love, art and religion with which we can again and again cover up that dark black hole. This endless solitude in eternity. Being alone.'[9]

The existential loneliness of the individual, whether in war or in crowded cities, was to Beckmann not due to the alienating anonymity of the crowd as such, but to the loss of 'oceanic feeling' it induced. 'The essential meaning of space is identical with individuality, or what mankind calls God.'[9] This positive personal philosophy enabled him to avoid the misanthropic nihilism which, to differing degrees, obsessed both the pre-war Expressionists and the post-war Dadaists in Berlin. 'For the Self is the great veiled mystery of the world . . . I believe in it and in its eternal, immutable form. Its path is, in some strange way, our path. And for this reason I am immersed in the phenomenon of the Individual, the so-called whole Individual, and I try in every way to explain and represent it. What are you? Who am I? Those are the questions that constantly persecute and torment me . . .'[11]

This search finds its first mature expression in 'Carnival'.

The Protagonists

Although the two unmasked faces in the painting are clearly based on closely observed individual physiognomies, neither person in fact posed for this work. Beckmann used sketches of given people or places only as a catalyst to his imagination, preferring to compose his final works from memory.[12] However, if we compare the rendering of the man and woman in 'Carnival' with the more naturalistic drawings and prints he made of them at about the same time, it becomes apparent that he has deliberately emphasized certain features in order to heighten their expressive intensity.

Fridel Battenberg

The woman in the centre is Fridel Battenberg (1880–1966), the wife of the Frankfurt painter Ugi Battenberg, with whom Beckmann had studied at the Weimar art school from 1900–3. It was on their doorstep that Beckmann landed one night in the autumn of 1915, still suffering from the nervous and spiritual crisis induced by the horror of war. As

Fridel recalled later, 'Beckmann came for a few days and stayed for four years.'[13]

As a result of his traumatic experiences, Beckmann felt he could not return to his former life in Berlin. Unable to take up the threads of his pre-war image as the 'German Delacroix' whose work was seen as 'a grand synthesis of the pathos of Rubens, the light of Rembrandt, and the brushstroke of the Impressionists', he had to make a complete break with his artistic past.[14] By remaining in Frankfurt, though with regular return visits to Berlin, he created a situation in which he could rethink his aesthetic position. Indeed, from 1915–c.1925 he actively cultivated his self-imposed role as the detached observer. In order to achieve his desired 'objectivity of the inner face' Beckmann instinctively knew that he had to isolate himself from both the 'false and sentimental cancerous mysticism' of Expressionism[15] and the cultural anarchy of the Dadaists.

The Battenbergs gave him the practical and moral support he needed: Ugi even generously gave him his studio. Beckmann remained closely attached to them for the rest of his life. Fridel was a cheerful, warm-hearted and loving personality who sang beautifully and composed her own settings to poems by, among others, Rilke and Elizabeth Barratt-Browning. She was also a talented pianist, and played for Beckmann whenever he wished. In the words of a mutual friend: 'It is inconceivable that Beckmann was not fascinated by Fridel . . . she gave him the inspiration and the beauty he probably needed and of which he did not always perhaps have enough.'[16]

Beckmann's portraits of her, mostly done between 1915 and 1923, all focus on her large, expressive eyes and her intriguing combination of feminine warmth and feline grace. So fascinated was he by the latter quality that he affectionately nicknamed her after her cats.[17]

These qualities are also evident in 'Carnival'. Gracefully poised in the fanciful costume of a Commedia dell'Arte Columbine, Fridel clasps a violin protectively to her body and points her carnival slapstick or fan meaningfully at the man beside her, while gazing ahead, lost in some private reverie. To emphasize this spiritual quality Beckmann gave her an expressively large head in the manner described by Simon. Her gently sinuous pose evokes the spiritual eloquence of a Gothic Madonna or saint[18], while her provocatively crossed legs hint at the coquettish sexuality of a contemporary film diva. It may also reflect Beckmann's stated love of the exuberant rhythms of modern dances such as the one-step, the tango and the Boston.[19] Fridel's pivotal position in the work possibly echoes her importance to Beckmann at the time. However, the aura of gentle inwardness she radiates seems somewhat incongruous in the context of a carnival party.

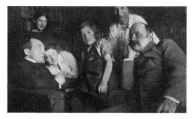

6 Beckmann and Fridel Battenberg (left) with Ugi Battenberg (right) at the house of friends, Frankfurt 1916 or 1917

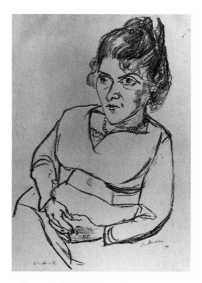

7 **Portrait of Fridel Battenberg** 1920 lithograph *Private Collection*

I.B. Neumann

I.B. Neumann (1887–1961), the figure on the left, is dressed as a Commedia dell'Arte Harlequin. Despite his intimate proximity to Fridel Battenberg in the painting, it is not certain they ever met.[20]

Neumann was one of the first people in Germany to grasp the significance of Beckmann's new 'difficult' style, and the only dealer prepared to exhibit it before 1919.[21] Beckmann's extensive correspondence with Neumann reveals his deep gratitude and indebtedness to him, especially during the years of uncertainty and self-doubt which necessarily accompanied his artistic re-evaluation.[22]

What emerges from these letters is that their understanding went far beyond the mutual respect and self-interest of the usual artist-dealer relationship. They recognized in each other the thinking being struggling to come to terms with a tragic period in history. 'By the way', Beckmann wrote to Neumann on 7 November 1920, 'I *too* appreciate what you are doing and at what cost to your nerves. I know all too well what it must be like to wade through all these incomprehensible pictures and to counter the endless stupidity, illogicality and intrigues without losing one's courage and faith in the existence of something whole. You *too* have something whole within you. The loneliness we both feel is probably because there are so few whole people. Most of them are mere pygmies. That is what is so tragic. How wonderful that we have each other. That gives me strength. . . .'

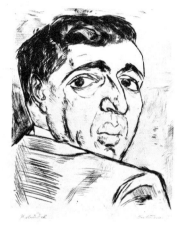

8 **Portrait of I.B. Neumann** 1919
drypoint *Städel, Frankfurt*

This emotional and spiritual bond is poignantly reflected in the Harlequin's sensitive, ascetic expression as he gazes with almost visionary intensity off to the right. In making us aware of the existence of a wider space beyond the frame, this simple gesture renders still more contradictory the claustrophobic space in which the three figures seem otherwise hermetically sealed. Neumann's spiritualized demeanour also contradicts the traditional comic role of the Harlequin he is ostensibly playing, and thus throws further doubt on the nature of the carnival we are witnessing.

Neumann's account of his first encounter with 'Carnival' affords a fascinating insight into Beckmann's method when working on a major 'statement' picture such as this:

'I was dumbfounded. For six months he had been labouring to bring forth this conception of *The Carnival*, and there had never been so much as a hint that he was working on me. Beckmann had long been talking about the "inner face". Nothing struck me so forcibly in this picture as the impression he had really done my portrait "from within". He had brought to the surface a deep melancholy of which I myself had not been fully aware until I stood there before the canvas "mirror" which Beckmann had put before me. Sensing my reaction, he said to me. "I was always soaking you up!" Now I realized that he really had been looking through me!'[23]

It thus becomes clearer what Beckmann meant by 'objectivity of the inner face': as he later wrote, 'to show the idea concealed behind the appearance of reality . . . to comprehend the magic of reality and to transfer this reality into painting'.[24]

Max Beckmann

The only figure who seems to be entering fully into the carnival spirit is the monkey-masked Clown lying on the floor wielding a trumpet precariously in his bare feet. Beckmann later confirmed that this was a self-portrait,[25] but in any case, as Neumann states, 'despite the disguise, his intimates recognized Beckmann in the delineation of his right hand, which is itself truly a portrait'.[26] But this does not explain why he chose to portray himself as a clown, especially given that, as he told Neumann, he was 'nearly always in a state of acute rage' at the appalling state of post-war Germany.[27]

Perhaps the first clue may be gained from his position in the composition, literally wedged under the feet of the two people on whom he depended most at this extremely difficult period of his life. The Clown's quasi-dadaist action may be construed as an irrational infantile tantrum.[28] However, it is also possible to see in it the anxious attention-seeking of the child who feels ignored or misunderstood by the world. In other words, it is a metaphor not only for the artist's hopeless rage at the misery of the world, but also for his distressed anger at the general incomprehension of his penetrating depiction of it. Just as Fridel and Neumann appear to be largely unaware of each other's presence, neither of them takes any notice of the forlorn, wildly gesticulating figure at their feet.

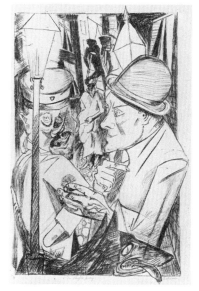

9 **Going Home** 1919
lithograph from *Die Hölle*
Beckmann as the moral conscience of the bourgeoisie acknowledging the terrible human suffering caused by the war
National Galleries of Scotland

Carnival

The Clown's unreason places him in a different order of things from the wistful self-knowledge of the other figures. It begins to seem more than coincidental, especially given their precisely defined pictorial relationship, that the latter belong to the artificial realm of the Commedia dell'Arte, whereas the Clown with his motley jacket orginates from the folk tradition of carnival.

The role of the Fool or Clown in carnival dates from ancient times. Originally, carnival was a ritual symbolizing the death and resurrection of the fertility god in spring. During this fertility rite winter, or death, was frequently personified by phallic demons who, because of the comical nature of their obscene mime, came to be regarded as clowns. Later the misconception arose that the dead fertility god was an evil

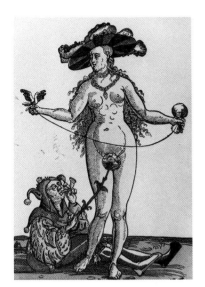

10 German School, **The Fool and Fertility** *c.*1505 woodcut
Biblioteca Gabinetta delle Stampe, Monaco

spirit, a shift which fundamentally altered the nature of carnival. It then evolved into a dramatic, even deadly combat between winter and summer, symbolized by mock battles with sticks and wooden swords to kill off the evil spirit and promote fertility.[29] The vestiges of this ritual are still to be found in the masked processions which take place at carnival time, although the wooden swords have long been replaced by harmless folded cardboard or paper slapsticks.

The spirit of the original phallic demon can be seen in Beckmann's clownish self-portrait. Although he is not actually using his slapstick to touch either of the figures as befits carnival banter, he holds it at an unmistakably phallic angle up towards Columbine.

Iconographically, such an interpretation is not without precedent. For example, in an anonymous German woodcut of *c.*1505, based on a popular poem by Hans Sachs, the Fool is shown lying on the ground sexually arousing a naked woman with a flower, the symbol of fertility. At the same time he blows his horn so that others may share vicariously in his act of titillation, although he shows no intention of satisfying the lust he has aroused. The woman is so absorbed with herself as desirous and desirable that she appears to be oblivious of his action.[30] The Fool's irresponsible passivity is echoed in the infantile impotence of Beckmann's Clown.

His monkey mask and the ostentatiously displayed baboonlike marking on his pants further stress the erotic element. Since ancient Greece the monkey has been seen as a grotesque caricature of man who, blinded by his vanity, imagines himself to be a man, unaware that only he is taken in by his self-deception. In the Middle Ages the monkey's promiscuity was used as a symbol of man enslaved by his animal instincts. Thus in Sebastian Brant's 'Ship of Fools' a monk who, together with two fools, is symbolically held on a leash by Venus, points to the symbol of his lust, a monkey which raises itself just enough off the ground to reveal its prominent behind.[31] This led the Neo-Platonists to designate the ape as man's Lower Soul, the reason for its appearance as the attribute of Michelangelo's 'Slaves', personifying the human soul enslaved by matter.[32]

Whether in 'Carnival' this symbol is intended to be read on a personal level must remain hypothetical. What is far more important is that through the combined symbolism of carnival clown and monkey mask Beckmann has transcended the level of mundane reality to make a universal statement. For the Clown's action, while stressing his prurience, paradoxically implies the irrational yet wilful denial of his animal nature, and thus a breakdown in the natural evolution of life.

This may well be intended as an ironical comment on Beckmann's own pre-war espousal of Nietzschean vitalism,[33] or as an oblique criticism of the post-war Expressionist writer's idealistic hope in the renewal of society through a vague utopian dream of creating the 'new man'.[34] Equally, it could be an ironic reference to Beckmann's own

feeling of powerlessness at mankind's rejection of the truth about its fate to which he felt morally bound to give concrete expression: 'We must surrender our hearts and our nerves to the terrible screams of pain uttered by the poor disillusioned masses . . . Our thoroughly superfluous and selfish existence can only be motivated by giving our fellow-men a picture of their fate, and this can only be done if you love them'.[35]

The World as a Madhouse

It may at first sight seem contradictory that the Fool should be unmasking the tragedy of the world. Yet it will be remembered that this device has frequently been used in literature since classical times. As Enid Welsford observes in her history of the Fool, 'Where the classical hero focuses events, forces issues and causes catastrophes, the Fool by his mere presence dissolves events, evades issues and throws doubt on the finality of fact'.[36]

To fifteenth-century man, the ambiguity of madness symbolized the 'dizzying unreason of the world'. The Fool was seen to possess the knowledge of man's ultimate being of which rational man with his mundane wisdom had only a fragmentary grasp. Thus madness was seen to lie at the heart of reason and truth: closer to reason than reason itself. In Foucault's words, 'Madness deals not so much with truth and the world, as with man and whatever truth about himself he is able to perceive.'[37]

Beckmann adopts the disguise of the Fool in 'Carnival' as a metaphor to reveal the 'inner face' of the political chaos and social distress of postwar Germany. The seeming madness of the world, externalized in the symbol of the Fool, is thus paradoxically shown to originate within man himself. That this is a central element in the conception of 'Carnival' is evident from the fact that the Clown is present in all but the first sketch, with very little essential modification. By fusing this with the symbol of the monkey, the paradox is doubled; only through wilful self-deception does man blind himself to the true nature of his dilemma.

'Carnival' marks the beginning of Beckmann's lifelong identification with the paradoxical truth of the Clown or Fool. In 'Self-Portrait as Clown' 1921, he adopts the same monkey-clown persona, but emphasizes the arbitrary nature of his role-playing by presenting himself 'between the acts'. What emerges is the tragic vulnerability and despair that lie beneath the symbolic, life-giving anarchy of the mask and slapstick. He holds these carnival attributes almost apologetically in the same hand as his cigar which, like the box of cigars and bottles of wine in 'Carnival', symbolizes the transient pleasures of the world.

During the 1920s Beckmann turned from the veiled myth of the Fool

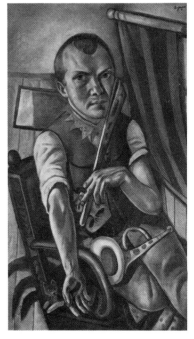

11 **Self-portrait as Clown** 1921
Von der Heydt-Museum, Wuppertal

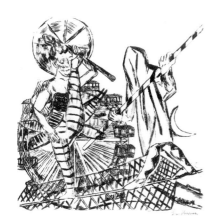

12 **The Tightrope Walkers** 1922
drypoint from *Jahrmarkt*
Private Collection

to the more explicit symbolism of the circus, fairground and variety show in order to comment on the arbitrariness of life, as in 'The Tightrope Walkers' 1921, an emblematic portrait of himself and his wife. During World War II, however, he returned to the more open symbolism of the Clown as an absurdist survival metaphor. In the right wing of the 'Acrobats' triptych, completed in August 1939, two clownish revellers intoxicate themselves with music and champagne in order to ignore the ominous advances of Mars behind. This panel reveals striking parallels to 'Carnival'. Not only is its format almost identical, it also contains several motifs from the 'Carnival' sketches which Beckmann did not use at the time, notably the arch framing the central female (Sixth Sketch) and the two carousing circus clowns huddled in the foreground (Eighth Sketch).[38] In both works the upper half is dominated by the antithesis between the male and female principle, formally offset against the absurd antics of the clownish principle in the lower half. In later carnival paintings, e.g. 'Carnival Paris' 1930, the 'Carnival' triptych 1942–3, and 'Masquerade' 1948, the vital, life-giving antithesis between the sexes, also discernible in 'Carnival' 1920, sharpens into a deadly combat reflecting Beckmann's increasing pessimism about humanity in reaction to Nazism.

13 right: **Acrobats** triptych 1939
(right wing)
St Louis Art Museum (Morton D. May
Bequest)

14 far right: **Carnival Paris** 1930
*Bayerische Staatsgemäldesammlungen,
Munich*

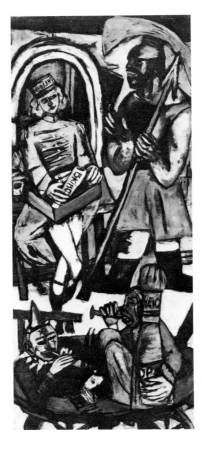

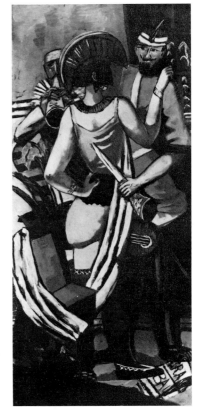

Commedia dell'Arte

Given the symbolic reasons for depicting himself in 'Carnival' as a Clown, why did Beckmann portray Fridel Battenberg and I.B. Neumann in the guise of characters from the Commedia dell'Arte?

Fridel appears as Columbine, who in the original Commedia scenarios represents the spirit of love.[39] Although a peripheral figure in the plot, she is nevertheless involved in the intrigues. In eighteenth-century France she evolved into the dainty, lively and flirtatious type depicted in Watteau's 'The Italian Comedy' 1716 in Berlin, which Beckmann probably knew.

This youthful vivacity is evident in the First Sketch for 'Carnival' in which she holds her mask out provocatively towards the taciturn figure of Pierrot, alias Beckmann. In the next two sketches she joins the Clown, the artist's second disguise, in threatening the other figure with a carnival sword or slapstick. In subsequent sketches she assumes the more passive, inward stance shown in the painting. One significant feature of the first sketch, her coquettishly crossed legs visible beneath the eye-catching zigzag hem of her dress, dropped in all but the Fifth and Sixth Sketches, is retained in the final composition.[40] But this explicitly suggestive pose is strangely at odds with her defensive gestures and contemplative expression. Any notion of carnival banter has vanished from the ambiguously purposeful way she points her slapstick at Neumann.

Harlequin, the Commedia dell'Arte character represented by I.B. Neumann, is a far more complex issue. Close study of the sketches reveals that this figure underwent more changes than any other in 'Carnival'. A fusion of fertility demon and medieval court jester, in the Commedia he wears a tight-fitting spangled costume based on the jester's motley, a broad hat and a black half-mask. His comedy is based on a juxtaposition of wild acrobatics, slapstick, bawdy and sharp wit. It is the latter which distinguishes him from the Clown or Fool. Existing outside the bounds of conventional morality, Harlequin is always ready to dissemble or deceive. But there is nothing malicious about him; his actions are lighthearted pranks.[41]

The melancholy figure in 'Carnival' clearly has little in common with the original Harlequin beyond his modestly lozenged suit and mock sword. Analysis of the sketches shows the intricate evolution of the ideas Beckmann wished to convey through this figure.

The Sketches

In the first five sketches Neumann appears not as Harlequin, but as

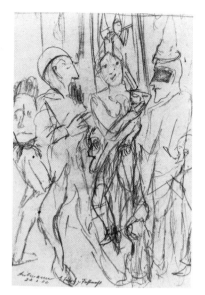

15 First Sketch for **Carnival** 22.2.1920
Private Collection

16 Second Sketch for **Carnival**
Galerie Nierendorf, Berlin

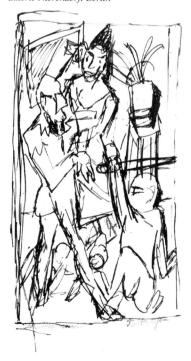

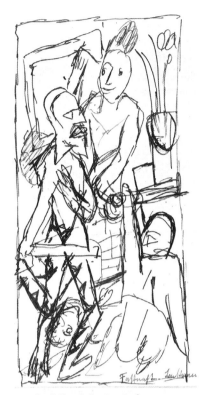

17 Third Sketch for **Carnival**
Private Collection

18 Fourth Sketch for **Carnival**
Trustees of the British Museum

Pantalone, the most dignified among the Commedia protagonists, whose entry on to the stage invariably opens the action. Dressed in red tights and jacket, a long black coat and a small black hat, he sports a distinctive brown mask with a prominent hooked nose and a pointed moustache and beard. Essentially a mature, serious type exemplifying shrewdness, wisdom, forthrightness and courage, he also represents the conflict between youth and age, occasionally abandoning his dignity to imitate the amorous intrigues of the young lovers.[42]

In the First Sketch for 'Carnival' Pantalone holds forth somewhat pompously, as he does in the Commedia, to the cooly detached Pierrot opposite. Although this sketch is the closest approximation to an actual stage setting, with bizarre little masked figures peering in at either side, it is the most static and vertical of all the designs.[43]

In the Second Sketch[44] there is a dramatic switch of roles. The masked Beckmann-Pierrot has been metamorphosed into a clown seated on the floor brandishing his sword wildly above his head, while Pantalone has donned a mask and points down reprovingly at the clownish absurdity at his feet.

In the Third Sketch a further radical transformation has taken place. Removing his mask, Pantalone's static pose has been superimposed by the bounding leap of Harlequin's lozenge-clad legs – that character's usual way of entering the stage. His left hand now points back over his shoulder, similar to the gesture in the final painting. Beckmann even considered having him do a somersault into the action, another typical Harlequin antic, as can be seen from the inverted head and hand added over the legs.

In the Fourth Sketch Pantalone, still with Harlequin's lozenges faintly indicated on his legs, has turned away and stalks off with his sword over his shoulder. Columbine gestures with what appears to be a fan, while the Clown, now crowned, continues to thrash the air with his wooden sword. The implication is that he is the victor of a typical Commedia duel, frequently occasioned by Pantalone's absurd amorous advances to Columbine. Beckmann here establishes the antithesis between rational judgement, even if spiced with folly, and clownish irrationality which features so prominently in 'Carnival'.

In the Fifth Sketch the Clown now sports Harlequin's lozenges and all three are engaged in a wild mock battle, with limbs, swords and carnival horns waving in all directions, creating a dynamic surface pattern similar to that in the painting. For the first time the worlds of Carnival and Commedia dell'Arte seem to be fused, and the motif of the Clown blowing a carnival horn is indicated.

In the remaining four sketches Beckmann introduces a significant iconographic shift which totally alters the mood of the scene. For while Columbine and Clown remain constant, the Neumann-Harlequin figure suddenly assumes the identity of Pierrot, the role Beckmann chose for himself in the First Sketch.

Pierrot

In the Sixth Sketch Pierrot, identifiable by his traditional pointed hat, moves into the scene towards Columbine. The suddenness of the iconographic change is indicated by the way his figure is superimposed over a pencil outline of Pantalone similar to that in the previous sketch. The two rather conspiratorial heads silhouetted in the arc shape framing Columbine lend a distinctly sinister note to the proceedings. For the first time the eye is led in along a sharp diagonal to focus on the interaction between Pierrot and Columbine which plays such a crucial part in the final painting.

Pierrot was established in the seventeenth-century Commedia scenarios as a slow-witted, lazy character, dressed in a baggy white suit with a large ruffed collar and a conical hat. His most memorable feature was his pathetic white-painted face which, unlike Harlequin's mask, he could not remove.[45] During the eighteenth century his static quality was stressed and he became the increasingly sensitive and isolated figure familiar to us from Watteau's 'Gilles' *c.*1718 in the Louvre. As such he appealed greatly to the Romantics who saw in him a symbol of the artist as the heroic outcast of society.[46] Owing to a compelling interpretation by the famous nineteenth-century French mime artist Debureau, Pierrot shed his clownish identity altogether and became virtually mute. The scene was thus set for his final transformation by the later Romantic poets into a symbol of 'splenetic pessimism and cosmic ennui'.[47] It was this idea which captured the imagination of artists as diverse as Daumier, Cézanne, Seurat, Ensor, Beardsley, Rouault and Picasso.

One of the most evocative early depictions of this 'modern' Pierrot as a symbol of introspection and alienation is Cézanne's 'Mardi Gras' 1888, in which even Harlequin seems to have been affected by Pierrot's detached wistfulness. The influence of this work on Picasso's enigmatic harlequins and acrobats of 1905–7 is well known.[48]

Similarities between the Neumann figure in 'Carnival' and the Harlequin in 'Mardi Gras' suggest that Beckmann was also familiar with the work.[49] Whereas Picasso responds to the simplicity of form and latent pathos, Beckmann is indebted to Cézanne's achievement in translating the subject into the abstraction of the surface, in order to 'contain volume in height and depth. Volume on the surface, depth conveyed by the feel of the surface, the architecture of the work'. Cézanne is one of the artists he refers to in his 'Artistic Confession' as having helped him develop a 'transcendent objectivity based on a deep love of nature and our fellow men'.[50]

In the Eighth and Ninth Sketches the Pierrot's pointed hat is transformed into a sinister 'head mask' totally enveloping the head and face. It is worth noting that this motif was based on the disguise Beckmann

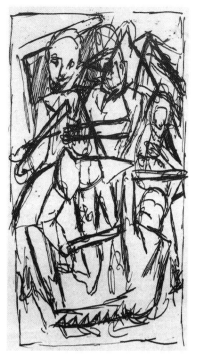

19 Fifth Sketch for **Carnival**
Kunsthalle, Bremen

20 Sixth Sketch for **Carnival**
Mrs Dorothy Zimmermann

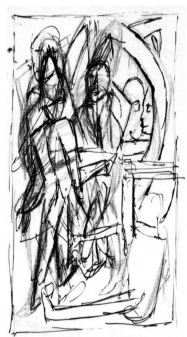

actually wore to a carnival party at about this time, as described by a close friend: 'I remember how he walked through the dancers, a giant figure in a black domino suit, a simple white woolen cap pulled right down to his neck with just two holes for inscrutable eyes. For one moment it flashed through my mind that this apparition, which remained silent throughout, actually felt it was a ghost.'[51]

Five years later Beckmann used this almost surreal intensification of Pierrot's alienation for his 'portrait' in 'Carnival: Pierrette and Clown' 1925, in which, as in the Tate's painting, he is identifiable only by his hand. His Pierrot hat is placed demonstratively in the centre beside Pierrette, played by Mathilde von Kaulbach ('Quappi') whom he married later that year. He painted it between 15 January and 28 February, spanning almost the whole carnival season, which that year coincided with his divorce from his first wife, Minna Tube. The complex feelings this doubtless aroused are expressed in the sharp contrast established between Quappi's girlish coquettishness and Beckmann's defensive withdrawal into the anonymity of disguise. The polarity of their moods is further stressed in the tense archetectonic structure and the predominance of cool blues and greens. As in 'Carnival', autobiographical elements are transformed through Commedia symbolism into an existential metaphor.

On 11 August 1925, just a few weeks before their marriage, Beckmann completed 'Double Portrait: Carnival' which reveals a far more optimistic interpretation of the carnival of life. Beckmann and his bride, having just symbolically entered a circus tent, are poised ready to

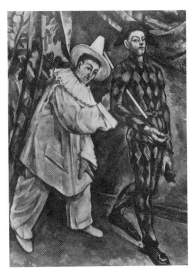

21 Paul Cézanne, **Mardi Gras** 1888
Museum of Modern Western Art, Moscow

22 Eighth Sketch for **Carnival**
Private Collection

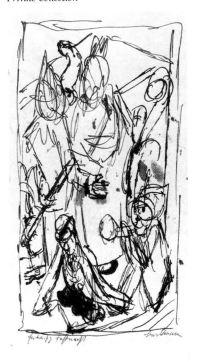

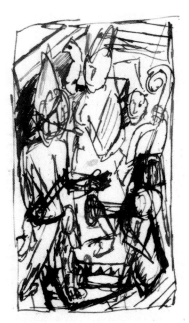

23 Ninth Sketch for **Carnival**
Mrs Dorothy Zimmermann

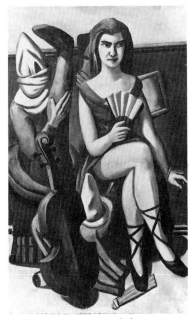

24 **Carnival: Pierrette and Clown** 1925
Kunsthalle, Mannheim

start their 'act'; the sexual challenge implied by her pose in the previous work is here transmuted into submissiveness, prefiguring the supportive role she would play in many later works. The cramped angularity of the previous scene is replaced by stable, vertical forms within a squarish format. Beckmann now identifies proudly with his artistic alter ego, Pierrot. His solid, frontal pose, cigarette dangling casually from his sensitive but powerful hand, exudes the self-confident sense of purpose appropriate to the artist whose hard-won 'transcendent objectivity' had, just six days before beginning this picture on 20 June, at last found public recognition at the famous *Neue Sachlichkeit* exhibition at Mannheim.[52] The regal purple of his costume resonates against a backdrop of warm ochres. The hussar outfit with hobby horse attached was actually worn by Quappi at a fancy dress party in Munich in 1925.[53]

The most personalized of all Beckmann's carnival paintings, 'Double Portrait: Carnival' seems to prefigure the words he wrote to Neumann a few months later: 'My marriage up to now is extraordinarily happy. And will remain so. I am still just a painter. . . . My will, now liberated, is building up uncanny powers for further advances. My major works are yet to come!'[54]

Although I.B. Neumann's Commedia persona in 'Carnival' does not correspond exactly to any of the sketches, his costume combines Harlequin's lozenges and Pierrot's ruff and buttons, and his bizarrely quiffed hair is a vestige of Pierrot's pointed hat. His demeanour blends Pantalone's earnest, responsible dignity with Pierrot's melancholic introspection. The short pants he wears over his Harlequin suit suggest an allusion to Picasso's mountebank harlequins.[55]

Musical Symbols

The Seventh Sketch introduces an element which features prominently in 'Carnival', namely the symbolism of musical instruments.

The seated Clown playing a trumpet and the double-bass player peering out from behind Columbine may be construed as adding to the carnival atmosphere; as such, they appear in the drypoint 'Pierrot and Mask'. However, the cello in the foreground has no logical function and thus demands to be read symbolically. Beckmann did not use this motif until the 1925 'Pierrette and Clown', where it is turned mysteriously away from the viewer echoing the hermetic mood of that work. Significantly, it is the only object in the sketches invested with the enigmatic autonomy which characterizes every object in the final painting.[57]

In 'Carnival' the cello's function is taken over by the Clown's trumpet. The evolution of this motif is evident in Sketches Seven to Nine, where

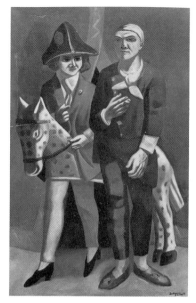

25 **Double Portrait Carnival, Max Beckmann and Quappi** 1925
Kunstmuseum, Dusseldorf

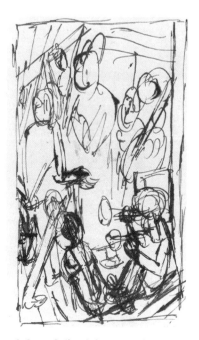

26 Seventh Sketch for **Carnival**
Private Collection

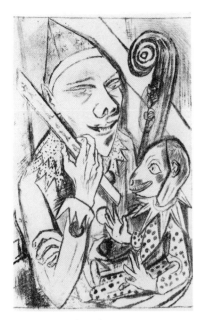

27 **Pierrot and Mask** 1920
lithograph *Victoria & Albert Museum*

the artist has worked over the Clown's lower back to create an abrupt diagonal emphasis. In the painting, his body is overturned and the diagonal emerges in the sharp angle formed by the artist's 'portrait' hand and the hem of his pants, thus calling attention to his ape-like behind. The trumpet, now released from functional banality, assumes the enigmatic force of a symbol.[58] This same detached quality is applied to Columbine's violin which she cradles in her arm like a Gothic Madonna holding the Christ Child.

The subtle precision with which the roles in 'Carnival' were cast also appears to apply to the musical instruments. In literal terms, of course, they are straightforward carnival attributes. However, the fact that the figures are neither playing them, nor indicating any readiness to do so, implies that the instruments' symbolic qualities are more important than their potential use. Like the carnival slapsticks, they are held up for show with all the deliberation and meaningful intensity of Gothic saints bearing the symbols which testify to their heroic faith. Beckmann's choice of a format similar to that often used for the side panels of altarpieces, in which saints and martyrs bear glorious witness to the promise of salvation through faith, may well be intended as an ironic comment on the faithlessness of his age. For whereas the saints are spiritually united in their individual contemplation of the Divine, the protagonists in 'Carnival' are paradoxically separated by the very action which ostensibly draws them together.[59]

To emphasize this paradox Beckmann chose to include instruments which in mythology are invested with conflicting meanings, being associated with both good and evil magic. For example, horns and violins are played by evil spirits at the witches' sabbath to entice and bewitch unwary travellers.[60] The analogy of life as a witches' sabbath, in which even the innocent are forced to participate against their will, echoes Neumann's perceptive comment about *Hell*, Beckmann's 1919 graphic cycle depicting the fear and brutality of post-war Berlin: 'Medieval hell could be escaped by the virtuous, but there was no escaping the hell that had engulfed us all.'[61]

The fact that Fridel Battenberg clasps the violin so protectively to her might perhaps be an allusion to the witchcraft myth according to which the violin, on account of its bewitching sound, was believed to transform itself into a cat.[62] The violin is another motif which features only in the finished painting, but the cat seated on the window-sill at the right appears in the last three sketches perched either on Fridel's shoulder or on a shelf behind.

The essence of this motif, especially as shown in the final sketch which establishes the taut formal relationship between her shoulders and the mirror on the wall, emerges in 'Portrait of Fridel Battenberg' 1920. It is therefore likely Beckmann made this portrait while 'Carnival' was in progress, possibly in order to clarify ideas he wished to express in the major statement. In 'Carnival' the violin not only alludes to the

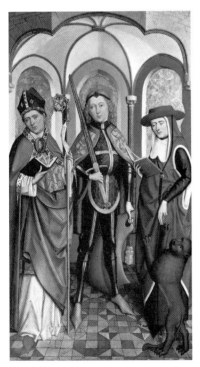

28 Circle of the Master of Liesborn,
Three Saints *National Gallery*

intimate link between Fridel and cats: in Neo-Platonic thought, when held by Amor, the violin symbolizes pure love, thus confirming the symbolism of her theatrical persona as Columbine, the spirit of love.[63]

The trumpet or horn can also forebode ill as well as proclaim good. Both were associated with the devil, and figure frequently in medieval depictions of the Dance of Death. But the trumpet was also believed in folk tradition to have the magical power to drive away evil spirits and sickness, and to bring help.[64] The most dramatic example of power symbolically invested in the trumpet occurs in the Book of Revelation where, after the opening of the Seventh Seal, the first six angels of the Apocalypse wreak disaster on earth at the sound of their trumpets, while the seventh angel's trumpet heralds the coming of the kingdom of God.[65]

Is the irrational misuse of the trumpet in 'Carnival' perhaps intended as an ironical allusion to what Beckmann felt to be the total absence of God's benign influence in the 'hell' of post-war Germany? Such an interpretation accords with his 1919 statement: 'In my pictures I accuse God of everything he has done wrong.'[66] It furthermore suggests that he selected the attribute specifically to give what he called 'transcendent objectivity' to the 'screams of pain uttered by the poor disillusioned masses'.[67]

Gesture

Having observed the slow metamorphosis of the Neumann figure in the sketches, it is hardly surprising that the complex hybrid that emerges should be furnished with the most enigmatic gestures, none of which has more than a vestigial link with the mock battles of the Commedia dell'Arte or Carnival. Gesture has also been invested with the force of an independent symbol.

The most significant gesture in 'Carnival' is Neumann's finger pointing purposefully back over his shoulder, emphatically echoed by Fridel's gesture towards him with her fan. Traditionally this gesture is used by the Angel Gabriel at the Annunciation to reveal the divine source of his joyful message to the Virgin Mary. However, combined with the intense spirituality of his gaze, Neumann's gesture does far more than simply indicate God's presence. It conveys the emotional drama of John the Baptist's declamatory finger pointing at the crucified Christ in Grünewald's Isenheim Altarpiece c.1515, which Beckmann had first seen in 1904.[68] He used this motif in 1919 in the lithograph 'The Family' to express his rage at what he felt to be God's betrayal of the world.

Formally we are led to see this gesture in conjunction with its opposite, the slapstick pointing demonstratively downwards in his

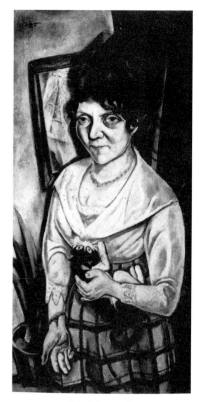

29 **Portrait of Fridel Battenberg** 1920
Kunstmuseum, Hanover

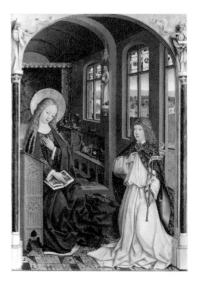

30 Master of Liesborn,
The Annunciation *National Gallery*

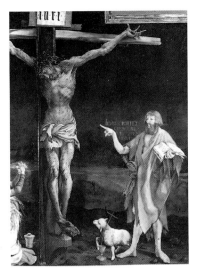

31 Mathias Grünewald, Isenheim Altarpiece, Colmar *c.*1515 (detail of **The Crucifixion**)

32 **Adam and Eve** 1917 drypoint
Victoria & Albert Museum

other hand, a motif which is first introduced in the last two sketches. In Christian iconography this gesture traditionally denotes hell which, given the slapstick's original ritual power to expel evil and create new life, adds an ironic twist to the carnival symbolism. That Beckmann is using these attributes and gestures to make an eschatalogical statement is clear. But to conclude, as previous critics have done, that it expresses a totally 'negative piety' devoid of any hope in God's mercy, is to ignore the subtle ambiguities and contradictions woven into the composition.[69]

Gnosticism

In about 1918 Beckmann began to study the doctrines of Gnosticism with which he had been at least superficially familiar since well before World War I through his reading of Schopenhauer.[70] It is not difficult to imagine a man whose off-duty reading during the war included both the New Testament and *Zarathustra* (the work in which Nietzsche formulated his concept of Superman and the transvaluation of values), turning to Gnosticism when he could no longer reconcile the pointless horror and suffering of war with the traditional Christian idea of the world as the creation of a good and loving God.

For the central tenet of Gnosticism is that the human soul is part of the First Light that has become separated from the Divine and has fallen into the world, a vast prison created by the evil Demiurge to keep it captive. Immersed in the human body, the emanation of evil matter, the soul is benumbed and unconscious of itself, intoxicated by the poison of the world.[71]

The Gnostic aim is to free the soul from the bonds of the world so that it may return to the Light. To attain this man must learn about his divine origin, and recognize the world as his place of exile; and his soul must become aware of its 'alienness', and become filled with longing for its original state.

In Gnostic thought the first act of rebellion against the oppressive Demiurge of material creation, and thus the beginning of all Gnosis, i.e. knowledge, on earth, is the serpent's action in persuading Eve to taste the forbidden fruit of knowledge.[72] In 1917 Beckmann made two versions of 'Adam and Eve', both dominated by a haunting, alligator-jawed serpent, in which Eve, with a somewhat whimsical expression on her face, offers Adam her breast instead of the apple mentioned in Genesis. In the painting Adam responds with a gesture of denial, while in the claustrophobic space of the drypoint he shrinks fearfully away from her. Beckmann is clearly not depicting the Fall, but Adam and Eve's reaction to the serpent's Gnostic action. According to Gnostic doctrine Adam's first reaction to the knowledge he receives about

himself is an outburst of acute terror, while Eve's provocative gesture symbolizes the Gnostic doctrine of Eros as the principle of mortality, sensual pleasure being seen as a form of man's ensnarement by the world.[73]

The strangely ambivalent festive gathering depicted in 'Carnival' also lends itself to interpretation as a Gnostic allegory. The monkey-masked clown on the floor symbolizes not only man's seduction by the senses, but also the Gnostic image of the soul slumbering in matter, benumbed by the evil of the world.[74] The bottles of wine and box of Havana cigars also symbolize the dangerous lure of worldly pleasures.

The Harlequin-Pierrot figure, by contrast, symbolizes the man who has heard the call. His awareness of his fallen state and divine origin is symbolized by his conflicting gestures. But instead of the terror which seized Adam, his penetrating gaze reflects the next stage of response to the call of Gnosis: 'the soul calls the Great Life to account for the existence of the world as such and for its exile there . . . it asks the great "Why?" which, far from being appeased by the awakening and reminder of its origin, is powerfully stirred by them.'[75]

Columbine's expression conveys the third stage of response, namely grateful acceptance of the promise of salvation: 'Adam heard and believed . . . Adam received Truth . . . Adam gazed upwards full of hope and ascended.'[76]

Gnostic symbolism is thus superimposed over the judiciously fused imagery drawn from the world of Carnival and the Commedia dell'Arte to evoke the artificial nature of the soul's passage through earthly existence, the imminent end of which is suggested by the snuffed and fallen candles on the window sill.[77]

Space and Structure

Beckmann has distorted the relationship between space and figures in order to give 'transcendent objectivity' to the Gnostic concept of the soul trapped in a finite world which it experiences as simultaneously vast and claustrophobically small. Space, experienced through time, is the demonic dimension by which man is constantly reminded of his 'alienness' in the world. Thus for Beckmann 'time is an invention of mankind; space or volume, the palace of the gods'.[78] Hence the paradox of people crammed so close together they can hardly move, yet totally separated by their individual perception of the reality they are experiencing.

The inherent contradictions and frustrations of mundane existence are conveyed by the formal and architectonic tensions established on the surface; not only between figures and space, but between all the figures and objects within that space. Whereas De Chirico had dis-

located space in order to heighten our awareness of the metaphysical reality of things, Beckmann's space is actually defined by the objects it contains to give concrete expression to our sense of alienation. 'I hardly need to abstract things, for each object is unreal enough already, so unreal that I can only make it real by means of painting.'[79]

All the objects in 'Carnival' are formally integrated into two distinct architectonic structures, which not only achieve Beckmann's aim to create volume on the surface, but also act as leitmotifs revealing the final layers of symbolism in the work.

One set of forms is determined by the steeply raked angle of Neumann's slapstick in relation to the equally sharp angle of his upheld finger and Fridel's fan. The resulting rhomboid configuration, echoed in numerous other forms throughout the composition, creates a psychological tension over the whole surface which gives formal expression to the conflict between man's material existence and his divine origin and destiny.[80]

The second system links the Clown's trumpet, the ambivalent harbinger of good and evil, with the gramophone horn, Beckmann's favourite symbol of the ambiguity of vitalism,[81] and the mirror just visible behind. The horn's suggestive red opening is placed close to the attentive ear of Fridel Battenberg, the Commedia dell'Arte spirit of love and the Gnostic symbol of faith in the soul's promised return to the Light. A small carnival whistle nearby is directed towards the ear of Neumann, the introspective Harlequin, giving 'transcendent objectivity' to his questioning reception of the Gnostic call. As with other objects in 'Carnival', their implied function is rendered mysteriously ambiguous, drawing our attention to the brightly coloured disc on the shelf behind, which largely obscures the mirror leaning against the wall.

This mirror is clearly crucial to the meaning of 'Carnival' as it is indicated in all but the First Sketch. Closer inspection reveals that Neumann is standing on a second mirror, almost entirely covered by the table cloth which has been dragged to the ground, uniting all three figures in its ominous shroud-like folds. Both mirrors are evidently significant for what they conceal rather than reveal. Hence Beckmann is not concerned with the mirror as a symbol of vanity, pride or lust which figures so frequently in Renaissance and Baroque allegories. Rather, he seems to be alluding to the ancient superstition that the mirror image contains, or is, the soul of the person reflected in it; hence the tradition of covering mirrors or turning them to the wall after a death.[82] The dance without end mooted earlier has turned into a Dance of Death.

The mysterious disc of bright blue, burgundy, scarlet, rose, yellow, orange and ochre rings which blocks any reflection in the mirror must therefore contain the key to the work's meaning. It too is a Gnostic symbol, representing the seven cosmic spheres through which the soul

had to pass or descend when it became separated from the Light. In each of these spheres it was clothed in another layer of corruption, gradually reconciling it to earthly imprisonment in the human body.

According to Gnostic thought, to regain its original nature as part of the Great Light, the soul must retrace its path through these spheres, shedding at each one part of its worldly 'clothing'. In some Gnostic cults this transformation was symbolically anticipated by ritual enactments, which sometimes included the successive donning and doffing of various garments and animal disguises which, it was believed, would guarantee its definitive realization in the next world.[83]

The various layered disguises of the actors in 'Carnival' thus represent different stages in the ritual rebirth of the individual soul. Far from concealing, these disguises are necessary to reveal a glimpse of man's original luminous nature, symbolized by the brilliant colours linking the three individuals with the cosmic spheres through which they must pass to regain their transcendental souls. The relevant stage attained by the three souls in their progress back to the Light is symbolized by the predominance of warm, sensual red and orange tones in the lower, earthbound part of the painting, while forms and features become gradually cooler, more ethereal and bathed in luminescence as they approach their final destiny, through the looking glass of their souls, back to the Light.

Footnotes

[1] *Fastnacht* does not derive from *fasten*, to fast, but from *faseln*, to talk nonsense or drivel, to have great fun, and thus designates an evening of feasting and fooling.

[2] Karl Linker, *Stadt unter Schellenkappe. Geschichte der Frankfurter Fastnacht*, Frankfurt 1977, p.87. In 1919 the city council tried to ban public *Fastnacht* celebrations, but the Frankfurt citizens, frustrated after the austerity of the war years, forced the police to give way.

[3] Stephan von Wiese, *Max Beckmanns zeichnerisches Werk 1903–25*, Düsseldorf 1978, No.455, verso.

[4] I.B. Neumann, 'Sorrow and Champagne', New York 1958 (chapter on Beckmann in Neumann's unpublished memoirs *Confessions of an Art Dealer*, typescript in the Neumann Archive, Museum of Modern Art, New York) p.16.

[5] Quoted in: Peter Selz, *Max Beckmann*, New York, Museum of Modern Art, 1964, p.26.

[6] Ibid., p.25.

[7] 'Artistic Confession', 1918, in: *Max Beckmann, Frankfurt 1915–1933*, Städtische Galerie im Städelschen Kunstinstitut, Frankfurt Nov.1983–Feb.1984, p.16.

[8] Heinrich Simon, 'Max Beckmann' in: *Das Kunstblatt 3*, 1919, p.675ff. Beckmann lived with the Simons in Frankfurt from July 1919 until early 1920. This closeness is reflected in Simon's analysis.

[9] *Briefe im Kriege* (Letters from the war), Berlin 1916, reprinted Munich 1955. Letter dated 24.5.1915. c.f. Selz, op.cit., p.23.

[10] 'On my painting.' English translation of the lecture Beckmann gave at the New Burlington Galleries, London, 21 July 1938. Reprinted in Herschel B. Chipp, *Theories of Modern Art*, Berkeley-Los Angeles 1968, pp.187–192; also in *Max Beckmann*, Marlborough Fine Art Ltd, 1974, pp.11–21.

[11] Ibid., Beckmann derived these ideas

from Schopenhauer's *Parerga and Paralipomena*, of which he had owned a copy since 1906.

12 Mathilde Q. Beckmann, *Mein Leben mit Max Beckmann*, Munich 1983, p.16.

13 Erhard and Barbara Göpel, *Max Beckmann: Katalog der Gemälde*, Berne 1976, Vol.1, p.130.

14 Selz, op.cit., p.19.

15 Comment on Expressionism in 'Artistic Confession'. Kokoschka and the Brücke artists were exhibited regularly in Frankfurt in the years after Beckmann's arrival there. In 1918 Beckmann wrote to Piper that 'Expressionism is after all just a decorative literary affair which has nothing to do with a vital artistic sensibility'. (Piper Archive, Munich). Matisse was also included in this condemnation.

16 Lili von Braunbehrens, *Gestalten und Gedichte um Max Beckmann*, Frankfurt 1966, pp.12–16.

17 Göpel, op.cit., p.146.

18 Reinhard Piper, *Nachmittag*, Munich 1950, p.32. Since 1915 Beckmann had been deeply moved by Old German and Netherlandish masters, and set himself the aim to emulate their emotional intensity but in the spirit of the twentieth century. c.f. Selz, op.cit., pp.23–30.

19 Letter to the Piper Verlag, Munich, March 1923 (Piper Archive, Munich).

20 Göpel, op.cit., p.148.

21 In November 1917 Neumann held an exhibition in Berlin of 110 prints and c.100 drawings, mostly done since 1914. The first exhibition of the post-war paintings was at Tiedemann and Uzielli's bookshop in Frankfurt in 1919.

22 Beckmann's letters to Neumann, 1920–39, are in the Municipal and University Library, Frankfurt, reproduced in *Max Beckmann: Frankfurt 1915–1933*, Städtische Galerie im Staedelschen Kunstinstitut, 1983, pp.266–289. Neumann's letters to Beckmann are no longer extant.

23 Neumann, op.cit., p.16.

24 'On my painting.'

25 Göpel, op.cit., p.147.

26 Neumann, op.cit., p.16.

27 Letter to Neumann, 7.11.1920.

28 Friedhelm Fischer, *Max Beckmann: Symbol und Weltbild*, Munich 1972, p.33.

29 Maxmilian Rudwin, *The Origin of the German Carnival Comedy*, New York 1920, p.14. See also C. Rademacher, 'Carnival' in: *Encyclopaedia of Religion and Ethics*, ed. J. Hastings, New York

1915.

30 William Willeford, *The Fool and his Sceptre*, London 1959, p.184.

31 H.W. Janson, *Apes and Ape Lore in the Middle Ages and Renaissance*, London 1952, p.29ff.

32 E. Panofsky, *Studies in Iconology*, New York 1962, pp.192–197.

33 E.-G. Güse, *Das Frühwerk Max Beckmanns*, Frankfurt-am-Main/Berne 1977.

34 Frankfurt was a major centre for Expressionist drama, e.g. Georg Kaiser's *Die Koralle* and *Gas* received their premières there in 1917 and 1918.

35 'Artistic Confession.'

36 Enid Welsford, *The Fool. His social and literary history*, London 1935, p.320.

37 Michel Foucault, *Madness and Civilization. A History of Insanity in the Age of Reason*, London 1971, p.14. (Trans. from the French, *Histoire de la Folie*, Paris 1961.)

38 Beckmann used motifs from the 'Carnival' sketches on numerous occasions in later years, e.g. the 'Carnival' triptych, 1942–3, drawing especially on sketch 7, which he kept until the 1940s, and sketches 6 and 9 which he kept until his death. The remainder he gave to Reinhard Piper, presumably in the 1920s, in exchange for books the latter had published.

39 Allardyce Nicoll, *The World of Harlequin*, Cambridge 1963, p.95ff. Beckmann's sources for Commedia dell'Arte imagery are not known, but there were a number of German publications on the topic at this time, e.g. Paul Ernst, *Pantalon und seine Söhne*, Berlin 1916.

40 This motif reappears in 'Carnival', 1942–3.

41 Nicoll, op.cit., p.67ff.

42 Ibid., p.44ff.

43 Von Wiese, op.cit., No.433. C.f. No.465.

44 Since von Wiese established his chronology (433–40) without seeing No.440, the sequence has to be slightly altered, as the latter sketch appears to be the sixth in order of execution. Hence von Wiese Nos.438 and 439 must now be considered as sketches 7 and 8 respectively. The small sketch owned by Mrs D. Zimmermann in New York, not included in von Wiese's list, will be placed as sketch 9.

45 Nicoll, op.cit., p.88ff. See also Robert F. Storey, *Pierrot. A Critical History of the Mask*, Princeton 1978, p.30ff for the French development of Pierrot.

46 Storey, op.cit., p.98ff.

47 Ibid., p.139. Cf. Baudelaire, Verlaine, and especially Jules Laforgues' *Complaintes* (1882), inspired by M. Sand's romanticized *Masques et Bouffons*, Paris 1860.

48 C.f. Theodor Reff, 'Harlequins, Saltimbanques, Clowns and Fools' in: *Art Forum* 10, Oct.1971, pp.36–43.

49 Cezanne's 'Mardi Gras' was reproduced in *Kunst und Künstler*, May 1903, p.191, during the Impressionist exhibition at the Berlin Secession. It was also illustrated in *Zeitschrift für bildende Kunst*, June 1913.

50 'Artistic Confession.'

51 Benno Reifenberg in: Göpel, op.cit., p.174.

52 14 June – 16 September 1925. That same year Franz Roh published *Nach-Expressionismus* (Post Expressionism) subtitled 'Magic Realism. Problems of the most recent European Painting', in which Beckmann figured prominently.

53 According to Marie Louise Motesiczky, in whose house in Vienna Beckmann met Mathilde von Kaulbach, the costume was made by her dressmaker in Vienna. The horse was decorated partly by Max Beckmann and, after he had to leave, completed by Marie Louise herself.

54 Letter to Neumann 25.1.1926.

55 Beckmann could have seen numerous illustrations of Picasso's acrobat and harlequin series.

56 This motif also appears in the painting 'Clown, pinkish-yellow', 1946.

57 See also 'Still Life with Cello and Double-Bass', 1950, referred to in his diary as a 'carnival still life' (7.1.1950).

58 Re. Beckmann's 'object symbolism' see Fischer, op.cit., p.85, and Armin Kesser in: *Blick auf Beckmann*, Munich 1962, p.29.

59 'Carnival' is Beckmann's first vertical painting and consciously echoes the aura of an altarpiece. Subsequently he adopts this format for all metaphysical statements in the 1920s, e.g. 'The Dream' (1921), 'The Trapeze' (1923), and 'The Boat' (1926). It clearly pre-empts the triptych format used for all major statements in the thirties and forties. In 'Carnival' (1942–3) the centre panel, for once significantly smaller than the side panels, has almost exactly the same format as 'Carnival' (1920).

60 Bächthold-Stäubli, *Handwörterbuch des deutschen Aberglaubens*, 1931

61 Neumann, op.cit., p.10.

62 Bächthold-Stäubli, op.cit.

63 See Henkel-Schöne, *Emblemata*, 1967;

Cesare Ripa, *Baroque and Rococo Pictorial Imagery*, 1971.

[64] Bächthold-Stäubli, op.cit. For Dance of Death, see e.g. Michael Wohlgemut, the *Nuremberg Chronicle*, 1493.

[65] Book of Revelation, Chs 8–11.

[66] Quoted in Reinhard Piper, op.cit., p.33.

[67] 'Artistic Confession', 1918

[68] Göpel, op.cit., p.17.

[69] Fischer, op.cit., p.34.

[70] Ibid, p.19, note 21. Also important in this context, H.P. Blavatsky, *The Secret Doctrine*, London 1888, of which Beckmann owned the fourth German edition, 1919.

[71] Hans Jonas, *The Gnostic Religion*, Boston 1963, p.42ff. Numerous books were published in German on Gnosticism between 1900 and 1920, e.g. E.H. Schmitt, *Was ist Gnosis?*, Berlin 1912, C. Barth, *Die Interpretation des Neuen Testaments in der Valentinianischen Gnosis*, 1914. However, it is at present not known which books Beckmann owned.

[72] Jonas, op.cit., p.93ff. See also H.P. Blavatsky, op.cit., vol.I, p.472.

[73] Ibid., p.72ff.

[74] Ibid., p.68ff.

[75] Ibid., p.88.

[76] Ibid., p.89. See also M. Lidzbarski (ed.), *Das Johannes Buch der Mandäer*, Berlin 1915, p.57.

[77] Bächthold-Stäubli, op.cit.

[78] 'Letters to a Woman Painter', a lecture given by Beckmann at Stephens College, Columbia, Missouri on 3.2.1948. In: Selz, op.cit., p.132–34.

[79] 'On my painting.'

[80] See Rudolf Arnheim, *Art and Visual Perception*, 2nd ed., Berkeley-Los Angeles 1974, p.245ff.

[81] Fischer, op.cit., p.84.

[82] See: Guy de Terravent, *Attributs et Symboles dans l'Art Profane*, Geneva 1958–9. Also A.E. Crawley, 'Superstitions connected with the Mirror' in: *Encyclopaedia of Religion and Ethics*, ed. J. Hastings, New York, 1915.

[83] Jonas, op.cit., pp.156–166.

Biographical Outline

1884
Born 12 February at Leipzig. Childhood spent at Brunswick and Falkenburg in Pomerania.

1900–3
Studied at the Weimar Art Academy under Frithjof Smith. Began to make prints.

1903
Summer 1903–March 1904 in Paris, where he saw the work of Manet, van Gogh and Cézanne.

1904
Visited Geneva and Florence, and saw Grünewald's Isenheim Altarpiece at Colmar. Settled in Berlin.

1905
Took part in the Berlin Secession. Awarded the Villa Romana Prize for six months' study in Florence. Married Minna Tube. Second visit to Paris in September.

1907–14
Lived at Berlin–Hermsdorf. Possibly met Munch in 1907.

1908
Birth of his only child, Peter. Third visit to Paris.

1909
Visited Nolde in his Berlin studio.

1910
Elected to the Board of the Berlin Secession, but resigned in 1911.

1911
I.B. Neumann began to publish his graphics. First one-man exhibition at Frankfurt am Main.

1912
Controversy with Franz Marc in *Pan*; rejected the Blaue Reiter's claim that art should be 'spiritual'. Met Ludwig Meidner who introduced him to Futurism.

1913
First one-man show in Berlin at Paul Cassirer. With Liebermann, Barlach, Pechstein and others left the Berlin Secession. First monograph on Beckmann by Hans Kaiser.

1914
Founder member of the New Secession in Berlin. Volunteered for the German army medical corps and sent to East Prussia.

1915
Transferred to field hospitals in Flanders. Commissioned to paint a mural (destroyed) for a delousing bath on the Western Front. Met Erich Heckel and Meidner at Ostend. Admired German and Flemish Old Masters in the museum at Brussels. Released from military service after a nervous breakdown. Settled in Frankfurt am Main with the Battenbergs, away from his wife and child.

1916
Letters from the War published by Bruno Cassirer, Berlin. Began series of religious paintings, in a harshly realistic style. Studied German Gothic art.

1917
First exhibition of graphics at I.B. Neumann, Berlin.

1919
Finished painting 'The Night'. Publication of two portfolios of graphics, *Faces* and *Hell*, charting his reaction to war and aftermath in Germany. First exhibition of post-war paintings at Tiedemann and Uzielli's bookshop at Frankfurt.

1920
Citynight lithographs, illustrating poems by Lilli von Braunbehrens, published.

1921
The Fairground portfolio published by Piper in Munich.

1922
Berlin Journey portfolio published by Neumann.

1923
Met Mathilde von Kaulbach ('Quappi') in Vienna. Visited Alfred Kubin in Austria. Neumann emigrated to New York.

1924
Retrospective exhibition at the Kunstverein in Frankfurt. Large monograph on Beckmann published by Piper with essays by Glaser, Meier-Graefe, Hausenstein, and Fraenger.

1925
Divorced Minna Tube. New contract with Neumann. Participated in G.F. Hartlaub's *Neue Sachlichkeit* exhibition at the Kunsthalle, Mannheim. Married Mathilde von Kaulbach on 1 September. Appointed Professor at the Staedelsches Kunstinstitut, Frankfurt.

1926
First American exhibition at I.B. Neumann in New York.

1926–32
Spent winter months in Paris.

1928
Large retrospective at the Kunsthalle, Mannheim and exhibitions at Berlin and Munich.

1929–30
September to May in Paris.

1930
Retrospectives at Basel and Zurich. Participated in XVIIth Venice Biennale.

1931
First one-man exhibition in Paris at the Galerie de la Renaissance. Included in the exhibition *German Painting and Sculpture* at M.O.M.A., New York.

1933
Dismissed by the Nazis from his teaching post. Moved to Berlin. Painted first triptych 'Departure'

1937
28 paintings and over 500 graphic works by Beckmann confiscated from German museums by the Nazis. Included in the *Degenerate Art* exhibition at Munich. Left with his wife for Amsterdam. Beckmann never returned to Germany.

1938
Took part in the exhibition of *20th Century German Art* at the New Burlington Galleries, London where he gave a lecture, 'On My Painting'. First of Curt Valentin's ten Beckmann exhibitions in New York.

1938–9
October to June in Paris.

1939
First Prize for triptych 'The Temptation of St Anthony' at the Contemporary European Art section of the Golden Gate Exhibition, San Francisco.

1940
Application for American visa rejected. When the Germans occupied Amsterdam, Beckmann burned his diaries from 1925–40.

1940–7
Lived in isolation in Amsterdam and executed over 200 works. Through support of dealers Helmuth Lütjens and Günther Franke, and his son Peter Beckmann, continued to sell paintings and receive commissions, mostly for graphics and book illustrations.

1947
Visited Paris and South of France in Spring. Accepted offer to teach at School of Fine Arts, Washington University, St Louis. Met Neumann in New York in November.

1948
Lectured at Stephens College, Columbia, Missouri ('Letters to a Woman Painter'). Large retrospective at St Louis and other U.S. cities. Returned to Amsterdam for three months before finally settling in U.S.A. in September and teaching a second year at St Louis.

1949
Taught at summer school, University of Colorado. Moved to New York in September to teach at Brooklyn Museum Art School.

1950
One-man exhibition in the German pavilion, XXVth Venice Biennale, where he received the painting prize. Died on 27 December a few hours after finishing triptych 'The Argonauts'.

Select Bibliography

Beckmann's Writings

Max Beckmann: Leben in Berlin, Diaries 1908–9, 1912–13, ed. Hans Kinkel, Munich 1966 and 1983.

Briefe im Kriege, compiled by Minna Tube, Berlin 1916; Munich 1955.

Tagebücher 1940–50, compiled by Mathilde Q. Beckmann, ed. Erhard Göpel, Munich 1955 and 1979.

Monographs, Memoirs and Other Studies

Beckmann, Mathilde Q., *Mein Leben mit Max Beckmann*, Munich and Zurich 1983.

Beckmann, Peter (ed.), *Max Beckmann: Sichtbares und Unsichtbares*, Stuttgart 1965.

Blick auf Beckmann, essays and documents, Max Beckmann Society, Munich, 1962.

Eberle, Matthias, *Max Beckmann: Die Nacht*, Frankfurt 1984.

Fischer, Friedhelm W., *Max Beckmann: Symbol und Weltbild*, Munich 1972.

Fischer, Friedhelm W., *Max Beckmann*, London 1973.

Göpel, Erhard and Barbara, *Max Beckmann: Katalog der Gemälde*, 2 vols, Berne 1976.

Güse, Ernst-Gerhard, *Das Frühwerk Max Beckmanns*, Frankfurt 1977.

Selz, Peter, *Max Beckmann*, New York 1964.

Wiese, Stephen von, *Max Beckmanns zeichnerisches Werk 1903–25*, Dusseldorf 1978

Exhibition Catalogues

Gallwitz, Klaus (ed.), *Max Beckmann: Die Druckgraphik*, Badischer Kunstverein, Karlsruhe 1962.

Max Beckmann, Arts Council, Tate Gallery 1965.

Max Beckmann, Marlborough Fine Art, London 1974.

Max Beckmann: Die frühen Bilder, Kunsthalle, Bielefeld 1982.

Max Beckmann: Die Hölle 1919, Kupferstichkabinett, Berlin 1983.

Max Beckmann: Frankfurt 1915–1933, Städtische Galerie im Staedelschen Kunstinstitut, Frankfurt 1983.

Max Beckmann Retrospektive, Haus der Kunst, Munich 1984.

Acknowledgements

I owe a special debt of gratitude to Marie Louise Motesiczky for her invaluable assistance at all stages of research and especially for her help in transcribing Beckmann's letters to I.B. Neumann; and to Dr Peter Beckmann, for his enthusiastic support.

I would also like to thank the following: Dr Margret Stuffmann, Keeper of Prints and Drawings at the Staedelsches Kunstinstitut, Frankfurt for many valuable insights during research on the Battenberg Bequest of Beckmann's graphics, and to Dr Klaus Gallwitz, Director of the Staedel; Mrs Dorothy Zimmermann, New York, for allowing me to reproduce her two previously unseen 'Carnival' sketches; Dr Christian Lenz and Dr Winfried Schulz-Mons, of the Neue Pinakothek in Munich, for placing all the resources of the Beckmann Archive at my disposal, and for constant encouragement during research; Mr Louis Karl, of Karl and Faber, Munich, for assistance in tracing the location of three of the 'Carnival' sketches formerly in the Piper Collection; Mrs Barbara Göpel; Dr Jens-Jürgen Häusgen; and Mrs Christa Maul.